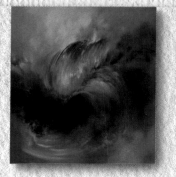

The Ocean

The sea has a rhythm of its own; it can appear calm and serene or stormy and choppy, depending on the weather and the pull of the tides. In this book, you'll learn how to depict several types of waves using a simple wet-into-wet oil painting technique. Artist Irene Lumgair demonstrates how to render the basic formations of waves from a variety of perspectives, as well as how to incorporate other marine elements—such as rocks, wet and dry sand, and foam—into your ocean paintings. And with each easy-to-follow lesson, you'll discover something new—from how to create colorful sunsets and seascapes with movement and action to techniques for invoking mood with fog, sunlight, or moonlight. The artist also shares tips on developing a composition, using values, and choosing supplies, making this book a wonderful guide to the art of painting oceans and waves.

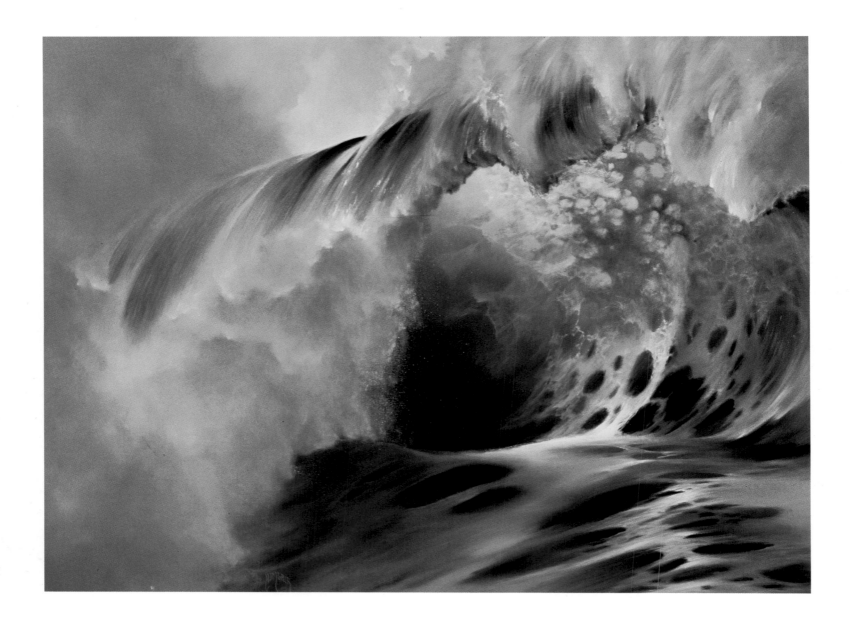

INTRODUCTION

The purpose of this book is to teach you how to paint the various components of waves—as well as some of the other elements of a seascape: sand, rocks, sunsets, and so forth. With practice, you will soon be able to use the techniques herein to paint your own original wave and seascape paintings.

I paint wet-into-wet, or *a la prima*, which means applying paint directly—in other words, painting layer upon layer without waiting for the paint to dry. The traditional method of oil painting, building wet layers over dry, thinner layers, is frustrating to me; I want the effect to happen instantly—like magic! When other artists look closely at my paintings to analyze what they thought they saw from three feet away, I want the illusion to disappear. When I press my nose against a painting and can count every blade of grass, I am disappointed; I want that magic!

Many of the demonstrations in this book are done with just three colors—burnt sienna, blue-black, and white. After attaining these effects with such a limited palette, the transition to full color is easy. You will see how burnt sienna covers the warm side (yellows, oranges, reds) of the color wheel and how blue-black covers the cool side (blues, greens, violets). All of the colors used in this book are listed on page 3.

TECHNIQUE

What is "my technique"? To me, it is simply how I see things and then paint them. I don't follow any particular rules or style. (I wonder where we got this idea of a prescribed technique—or worse, someone else's!)

If you are looking for "your" technique, just keep painting, sincerely trying to convey your views of the world, both inner and outer. Someday you will hear someone say, "Oh, these are *your* paintings? I recognize your work wherever I see it." Then you will know—your technique has found you!

Through experimentation, I have found that I can get the most out of my paint by using it in all consistencies—from thin to thick. This is because the same color mixtures in different textures reflect light differently.

Before we begin, I have one more word of advice: never try to repeat an effect exactly; strive to be as original as nature!

SUPPLIES

OIL PAINTS

*Full Color Palette**

Titanium White
Cadmium Yellow Light
Cadmium Orange
Red-Orange
Pthalo Red Rose (or Alizarin Crimson)
Pthalo Green
Pthalo Blue

*I recommend that you initially buy the small size tubes of the Full Color Palette colors (except for white). You will want to experiment with other colors later.

Demonstration Palette

White (large tube)
Burnt Sienna (small tube)**
Blue-Black (small tube)**

**You might later consider using these two colors on your regular full color palette. Burnt Sienna is useful to quickly warm a blue or green, blue-black to gray a warm color. The combination of these two colors is a reliable source for making grays.

BRUSHES

Four White Bristle Flats: #2, #4, #6, #8
Two White Bristle Fan Brushes: #4
(one for dark colors, one for light colors)
Two Script Liners: #1, #4 (these have long, thin, flexible bristles for painting details)

PAINTING KNIVES

I recommend that you purchase two painting knives, one with a rounded end for mixing paint and one that tapers to a point for dabbing in precise highlights.

CANVAS

The canvas shown below is an example of the type I use. I like its gray tint and rough but fairly regular tooth (texture). It is a cotton canvas, pre-primed with acrylic primer. If your art supply store does not carry gray-tinted canvas, you can mix your own primer and apply it before you begin your painting—or you can, of course, use white. A primed surface helps to hold paint in place while making changes or additions. A slippery or smooth-finish canvas makes changes difficult, while a rough canvas quickly wears down expensive brushes.

MISCELLANEOUS

Vine Charcoal
9" x 12" Paper Palette
Paint Thinner
Paper Towels
Easel

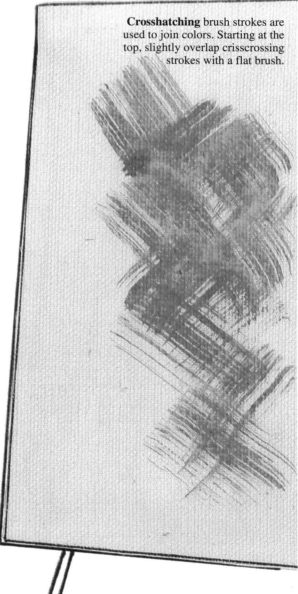

Crosshatching brush strokes are used to join colors. Starting at the top, slightly overlap crisscrossing strokes with a flat brush.

"Brush washers" are available at most art stores, or you can make your own: cut out a small square of 1/4" screening; use pliers to fold down 1" edges to fit inside your jar; place the screen at the bottom of your thinner jar.

When your painting is totally dry (after 6 to 9 months), you can spray it with Damar final varnish to create a uniform surface and to allow for future cleaning. Before the painting is thoroughly dry, a light coating of retouch varnish will create a uniform gloss and protect the painting.

A 3 lb. coffee can stuffed with paper towels is handy for wiping your brush without getting paint or thinner on your hands.

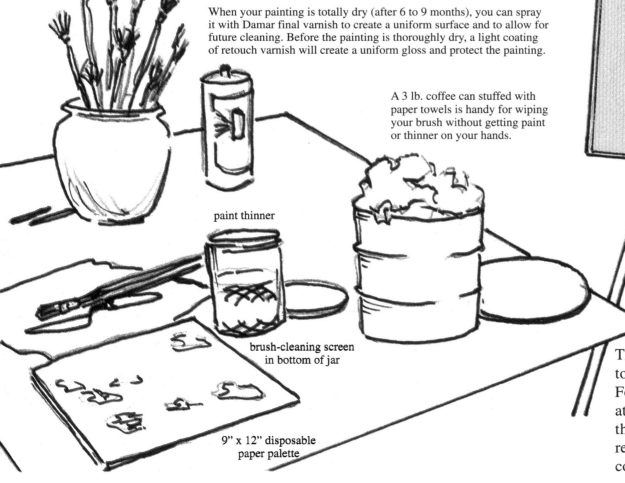

paint thinner

brush-cleaning screen
in bottom of jar

9" x 12" disposable
paper palette

I have a table next to my easel on which I place my materials.

The odor of paint thinner will remind you to work where there's good ventilation. Form habits to keep the paint and thinner at the opposite end of the brush from you; this will lessen the chance for allergic reactions to the chemicals. (You may also consider using odorless paint thinner.)

POINT-OF-VIEW AND COMPOSITION

The **point-of-view** of the scene is the first thing to be aware of when beginning a painting. For example, if you—the artist now, the viewer later—were standing on a bluff, the perspective in the painting would be entirely different than if you were standing at the water's edge. As you create your painting, keep the viewing point firmly in mind to maintain the proper perspective of the painting. (For further information, see Walter Foster books *Perspective*, #AL13, and *Perspective Drawing*, #HT29.)

The **composition** is the way in which the elements of a painting are arranged on the canvas. A good way to start the composition is to divide the surface space of your canvas into the shapes and areas of space that you see (or imagine) in your subject. These shapes can be both positive and negative; that is, you can draw the shape of the actual object (positive) or the space around it (negative).

Begin by lightly sketching the shapes with vine charcoal; this will allow you to experiment, changing and moving the elements around to make the composition more dynamic. Make the charcoal lines as light as possible—just a few small dots—until you are satisfied. When painting water, the less you confine yourself to a tight sketch, the more possibilities you will have for movement and excitement. Next, use a medium-size bristle flat brush with paint thinner and the tiniest bit of color (just enough to make the thinner visible) to go over the charcoal sketch. The thinner/color mixture will dissolve the charcoal so it won't taint subsequent layers of paint. (Note: Try to avoid filling the canvas weave at this early stage of the painting so as not to limit your choices later.) When your confidence has grown, along with your knowledge of the subject and medium, you can skip the charcoal step and do your minimal "sketch" with the brush and thinner/color wash.

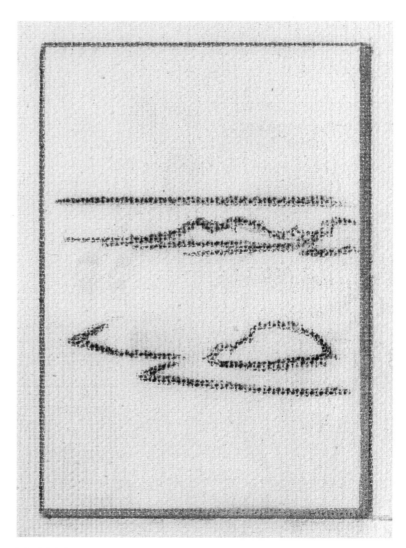

This sketch has been sufficiently suggested with charcoal. Placing the horizon low (one-third of the way up from the bottom of the canvas), lends an epic feeling with a lot of sky interest. This composition calls for an awareness of your viewpoint being very low—like that of a sand flea. Dramatic foreshortening of wave and shore perspectives would be indicated.

The high horizon indicates that the artist—or viewer—is standing on a bluff, looking down at the scene. Here more water surface is visible, allowing greater potential for wave or beach interest. The sky is incidental.

If you were standing on the beach looking out to the horizon, it would seem to be at eye level. One's natural reaction, therefore, would be to place the horizon about halfway down the canvas. Try to avoid this reaction. Dividing the canvas evenly in half creates a dull, static feeling. It also causes the top half to vie for attention with the bottom half, possibly making the viewer feel confused or uncomfortable.

The horizon is the only line in your composition that must be horizontal; you can, however, find ways to keep this element from becoming ordinary or monotonous. One way is to make a slight rise in the middle; this gives an illusion of looking out to the "edge" of the earth. Be sure that the bulge is centered, however, or you will make the viewer feel very uncomfortable.

Once you have placed the horizon, you must determine the other interesting divisions of the canvas surface. In a beach scene, you will usually see wave patterns making a succession of horizontal lines. Horizontal lines and shapes, however, are generally sedating; so if you don't want to put your viewer to sleep, try to limit your use of them. Verticals (lines or shapes going up and down), on the other hand, are agitating—too many will make the viewer want to escape. A third option is to use diagonals. Diagonals provide the tension of implied past or future action. (This is because they are leaning either forward or backward, so you ask yourself, "Which way will they fall?") Decide which attitude you want to express, and then choose the type of lines and edges that will convey that feeling.

Here the viewer is in the water.

In this example, fog or mist is concealing the horizon.

In this scene, the main wave action is close to the viewer.

Here the main wave action is in the distance.

The sky is the center of interest in this example.

The beach holds the interest here.

The two charcoal sketches directly above have been covered with a thinner/color wash, as described on page 4.

LOST AND FOUND HORIZONS

In a seascape painting, when we refer to the "horizon," we are actually referring to the place where and the manner in which the water visually meets the sky. The colors you choose for this area are not as important as the values—the relative lightness or darkness of the colors. The examples below demonstrate just four of the many possibilities.

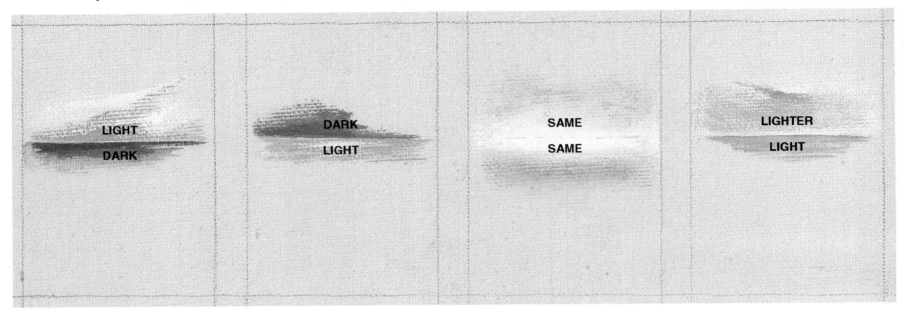

The use of a variety of value combinations across the expanse of the horizon can have the effect of condensing space.

From the vantage point of the beach, the combinations of these effects help to remind us of the vastness of our view.

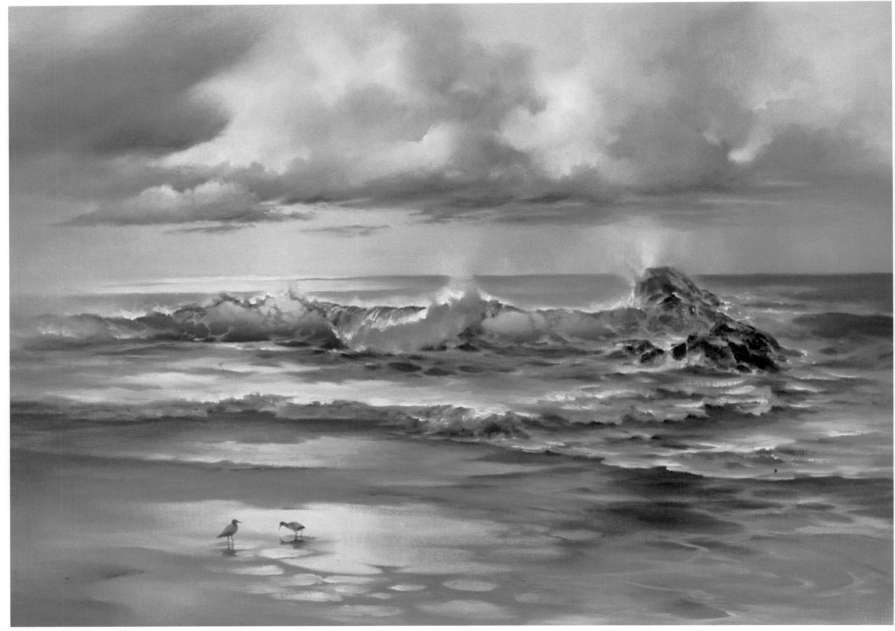

Find ways to keep the viewer's eye from following the horizon line out of the painting. There are several ways to do this: by making the outermost parts of the painting less interesting, by avoiding strong contrast areas near the edges, or by using elements of the painting—for example, the edge of a cloud—to direct the eye onto a diagonal track and back into the painting. When you must allow an eye path to lead off an edge, try to make it an upward curving line or shape; this helps to create an 'up' feeling.

A PALETTE OF WHITES (OR ANY VALUE 1 MIXTURE)

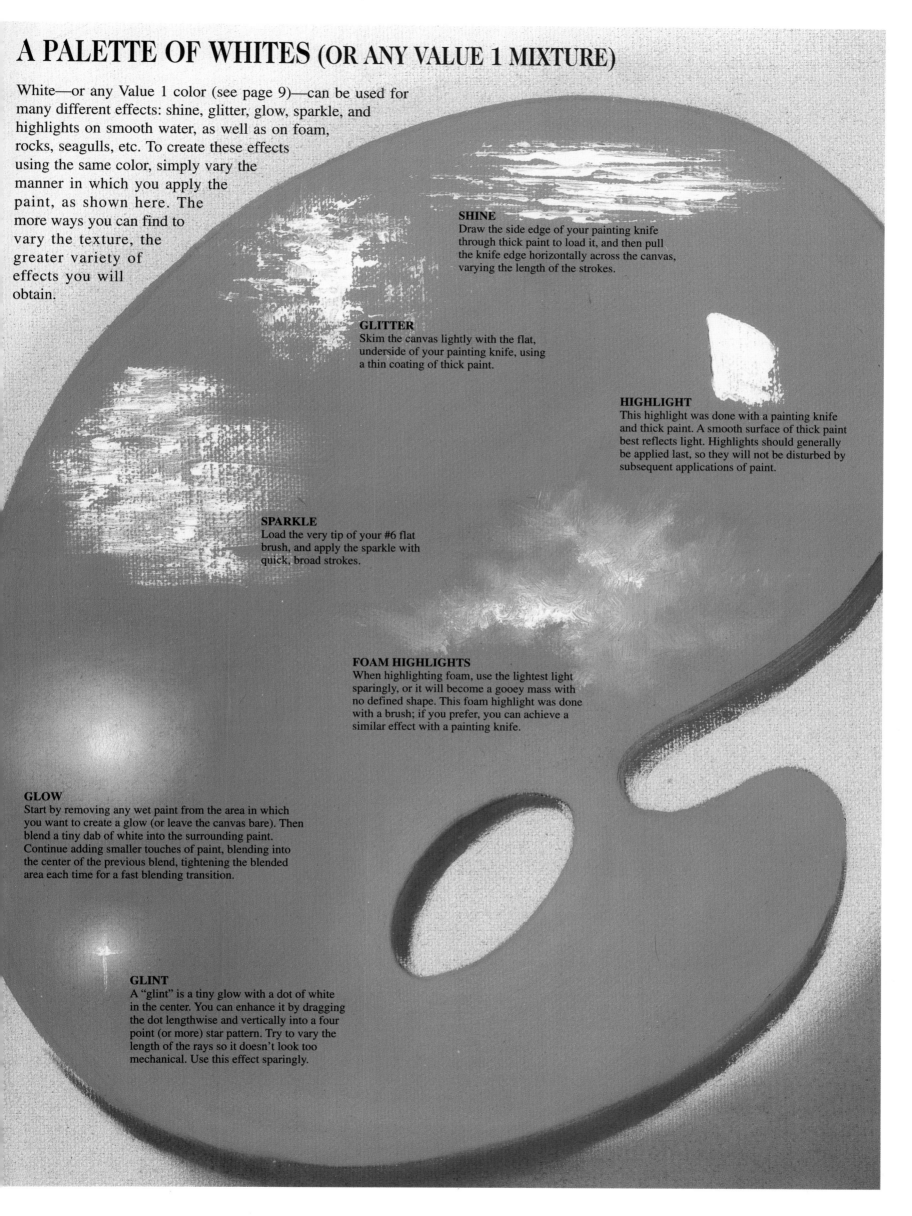

White—or any Value 1 color (see page 9)—can be used for many different effects: shine, glitter, glow, sparkle, and highlights on smooth water, as well as on foam, rocks, seagulls, etc. To create these effects using the same color, simply vary the manner in which you apply the paint, as shown here. The more ways you can find to vary the texture, the greater variety of effects you will obtain.

SHINE
Draw the side edge of your painting knife through thick paint to load it, and then pull the knife edge horizontally across the canvas, varying the length of the strokes.

GLITTER
Skim the canvas lightly with the flat, underside of your painting knife, using a thin coating of thick paint.

HIGHLIGHT
This highlight was done with a painting knife and thick paint. A smooth surface of thick paint best reflects light. Highlights should generally be applied last, so they will not be disturbed by subsequent applications of paint.

SPARKLE
Load the very tip of your #6 flat brush, and apply the sparkle with quick, broad strokes.

FOAM HIGHLIGHTS
When highlighting foam, use the lightest light sparingly, or it will become a gooey mass with no defined shape. This foam highlight was done with a brush; if you prefer, you can achieve a similar effect with a painting knife.

GLOW
Start by removing any wet paint from the area in which you want to create a glow (or leave the canvas bare). Then blend a tiny dab of white into the surrounding paint. Continue adding smaller touches of paint, blending into the center of the previous blend, tightening the blended area each time for a fast blending transition.

GLINT
A "glint" is a tiny glow with a dot of white in the center. You can enhance it by dragging the dot lengthwise and vertically into a four point (or more) star pattern. Try to vary the length of the rays so it doesn't look too mechanical. Use this effect sparingly.

WAVE COMPONENTS

Once your composition is roughed in, indicate where each action will occur on the main wave face. Try to keep the progression of action logical—for example, the point where the water is building up the highest is usually where it will begin to break and pour. Place the focal point (which is often the 'see-through' area) where you want the viewer's eye to be rewarded for following the interesting trail you have marked or pointed out within the composition.

This sketch shows the six most important visual components of a wave. These components are identified with the letters A through F and are explained briefly in the chart below. Each component is demonstrated in greater detail on the following pages.

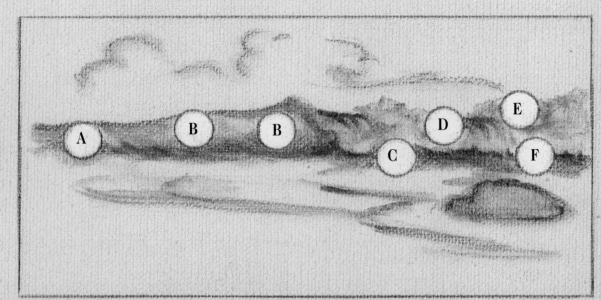

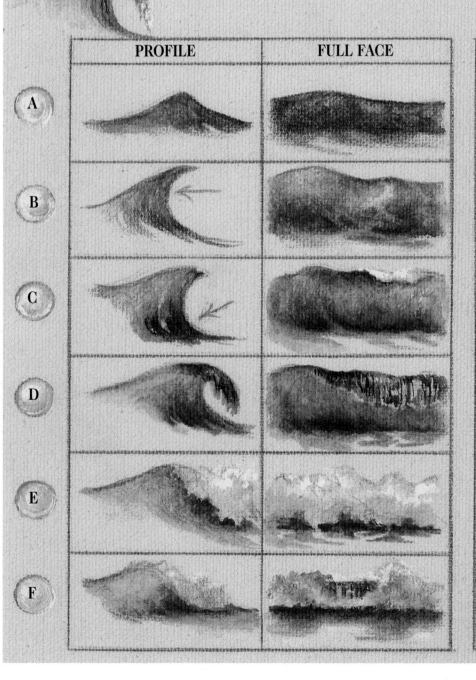

	PROFILE	FULL FACE	EXPLANATION
A			Here the water is building up to form the wave.
B			Here sunlight shows through the wave— I call it the "glamour spot."
C			The base of the wave (the thickest part) should be the darkest part.
D			This shows the water pouring over the top of the wave as it is breaking.
E			Here is an example of bouncing, frothy water both during and after the wave breaks.
F			Back-lit waves cast a shadow in front of the wave.

To demonstrate these wave components, I used only one warm color (burnt sienna) and one cool color (blue-black)—plus white. The reason for the limited palette is to show the importance of a color's value (how light or dark it is on a scale of 1 to 10), as well as the significance of the contrast of warm versus cool. Once you understand this concept, you will find it much easier to use color effectively, and you will learn to mix colors with their values and relative warmth or coolness in mind.

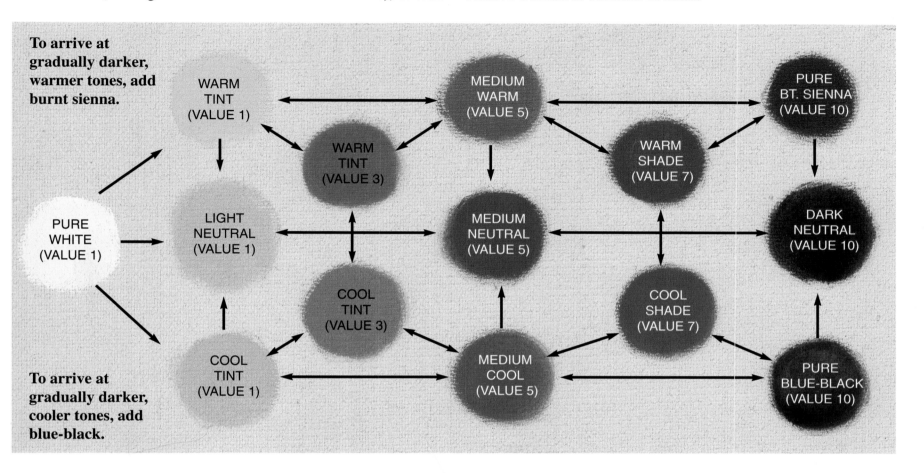

To arrive at gradually darker, warmer tones, add burnt sienna.

To arrive at gradually darker, cooler tones, add blue-black.

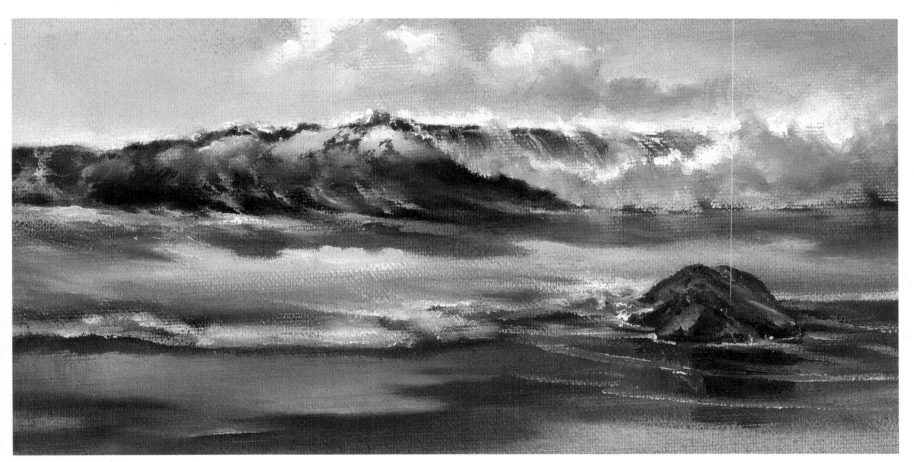

Here the sketch from the previous page has been developed into a bi-chromatic (two-color) seascape. The simplified palette above indicates the mixtures that were used. The detailed, step-by-step instructions for the various components are shown on pages 10 through 15.

A. WATER BUILDING UP TO FORM A WAVE

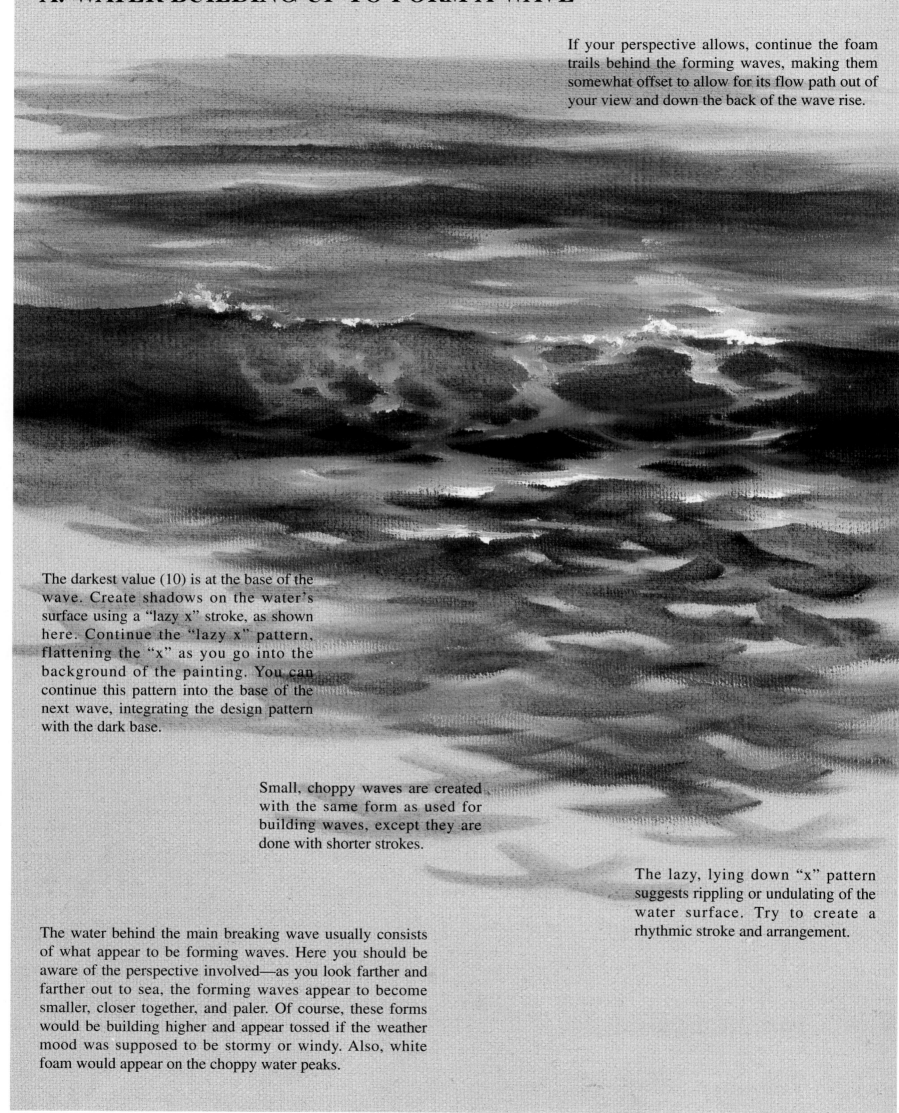

If your perspective allows, continue the foam trails behind the forming waves, making them somewhat offset to allow for its flow path out of your view and down the back of the wave rise.

The darkest value (10) is at the base of the wave. Create shadows on the water's surface using a "lazy x" stroke, as shown here. Continue the "lazy x" pattern, flattening the "x" as you go into the background of the painting. You can continue this pattern into the base of the next wave, integrating the design pattern with the dark base.

Small, choppy waves are created with the same form as used for building waves, except they are done with shorter strokes.

The lazy, lying down "x" pattern suggests rippling or undulating of the water surface. Try to create a rhythmic stroke and arrangement.

The water behind the main breaking wave usually consists of what appear to be forming waves. Here you should be aware of the perspective involved—as you look farther and farther out to sea, the forming waves appear to become smaller, closer together, and paler. Of course, these forms would be building higher and appear tossed if the weather mood was supposed to be stormy or windy. Also, white foam would appear on the choppy water peaks.

B. LIGHT THROUGH BACK-LIT WAVE

Use a large flat brush (the largest with which you feel comfortable) for the dark colors and a fan brush for blending from light into dark. Wipe off the fan brush often to keep the light areas clean. In areas where you want the water to appear as if light is shining through, add more blue-black paint at the base of the wave for blending upward. Also, add some strokes of pure burnt sienna to the wave base. Draw some of the burnt sienna up, above the base, and then touch some along the top of the wave to warm the transition when blending into the light (warm) area. Place white (or value 1 color) as shown.

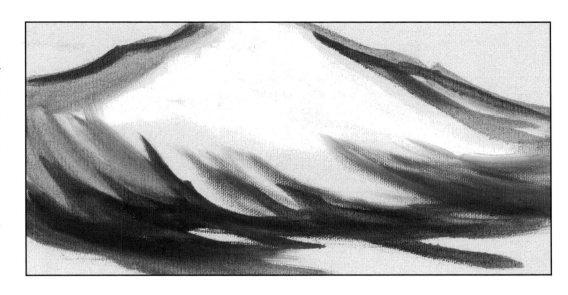

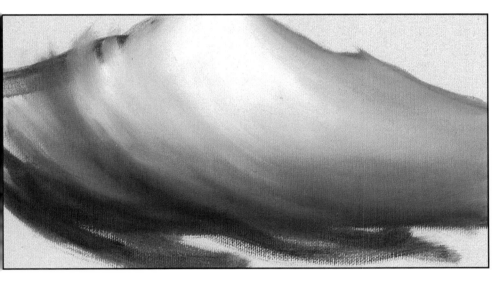

Start blending the color areas into one another. At first, limit your brush strokes to the transition areas, such as where white meets burnt sienna. After these colors are blended, mix the blended color on one side into the dark color and on the opposite side into the light. In this way, you will get some very fast color transitions. Wipe (don't rinse) your brushes often.

Add small touches of warm or cool and dark or light paint where needed. If a paint layer is too thick, it will be difficult to control the blending of color areas. Finish with feather-light brush strokes, first horizontally to fuse the color, then with sweeping, light strokes in the direction the water is moving.

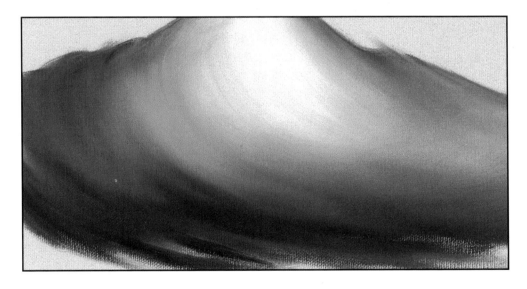

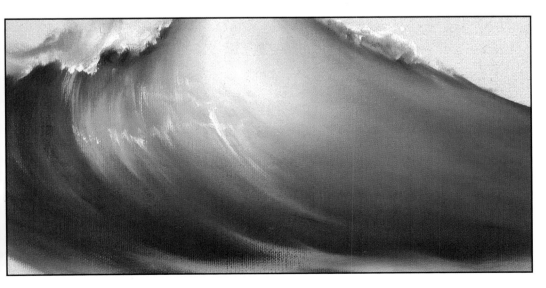

Now bring some reinforced dark streaks up from the base to exaggerate the thrust. Using a flat brush with sparse white paint, bounce and press the brush along the top edge of the wave where you want it to start toppling and breaking. Just under these suggestions of foam, shade with dark values. To create sparkle in the curl, drizzle a loose, jagged trail of light dots of paint, and then stroke over them very lightly in the direction of the surface water curl.

C. DARK WAVE BASE

The darkest part of a wave is also the thickest part—that is, the base. It is important to maintain a suggestion of mass all along the wave base, whether the wave is in the act of building, breaking, or tumbling. Use your #6 flat brush to dab in darks of burnt sienna and blue-black (value 10), both separately and in combination.

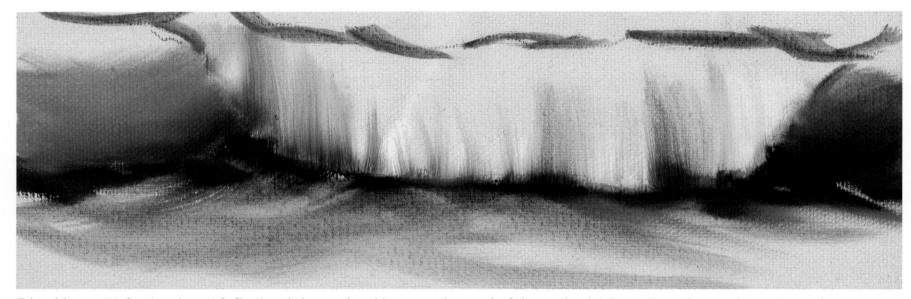

Dip either a #4 fan brush or #8 flat brush into paint thinner, and then wipe off the brush. Next, pick up a tiny edge of white paint and touch it very lightly into the dark wave base, pulling up at the end of the stroke. Make an irregular, random edge, trying to create varied colors. In a similar way, pull the darks under the wave down into the foreground water, as shown.

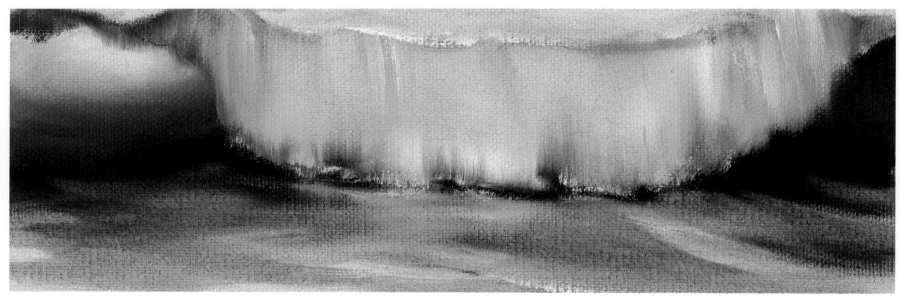

Continue dabbing and pulling the white edge until the frothy wave meets the dark underwave in a bouncing, varied rhythm. Where the white foam is heaviest at the bottom edge of the wave, suggest a reflection by pulling down with a dab of white. (While the white paint is on your brush, use it to suggest light hitting the top of the wave foam). Finally, reinforce the dark base in selected areas. These darks can also be pulled down as desired to create reflections.

D. POURING WATER AS WAVE BREAKS

The finished effect

At this point, the canvas is bare in the area where the water will pour. To indicate the glow of light through the mist just above the pouring water, start with a smudge of light pulled upward at the top edge using a #4 flat.

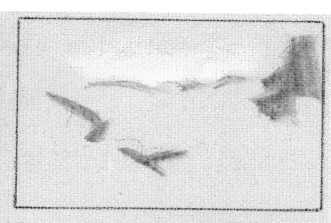

With a #6 flat brush, dab in dark colors, both warm and cool, along the top edge of the wave, just below and slightly into the mist. Set the brush aside.

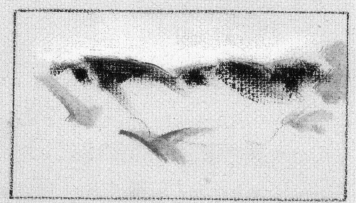

KEEP THE DIRECTION OF THE POURING WATER CONSISTENT

NOT LIKE THIS

With a #8 flat brush rinsed in paint thinner and wiped off, lightly pull downward from the lower, irregular edge of the darks. If you have a heavy touch, use a fan brush so the strokes can be feathered off where the foam begins.

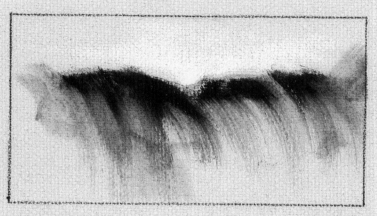

Using the unrinsed #6 flat brush, pull some pure color up and back, feathering it off into the mist above. Use fast, free strokes, wiping the brush at the end of each stroke so you don't pick up too much color. With either a #1 or #4 script liner brush, place dots and squiggles of white to indicate where light would hit the convex curve of the pouring water.

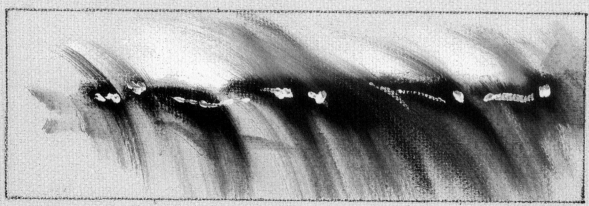

Use a light, flicking stroke to disperse the dots in the direction of the pouring water. Continue reinforcing a highlight here and there with dots and dispersing strokes. If you overdo it, you will need to revert to the fan brush dipped in paint thinner to remove the excess paint.

E. BOUNCING, FROTHY WATER AS WAVE BREAKS

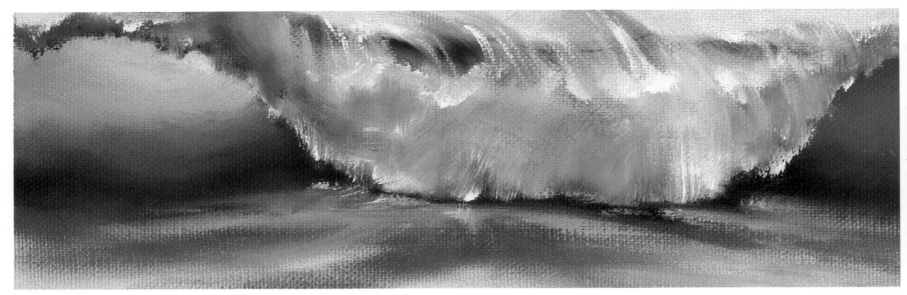

Here white has been applied to accentuate the top of the foam area, as well as to soften and blend certain areas. Crosshatching (see page 3) is used to combine component "C" on the lower part of the wave and component "D" on the upper part.

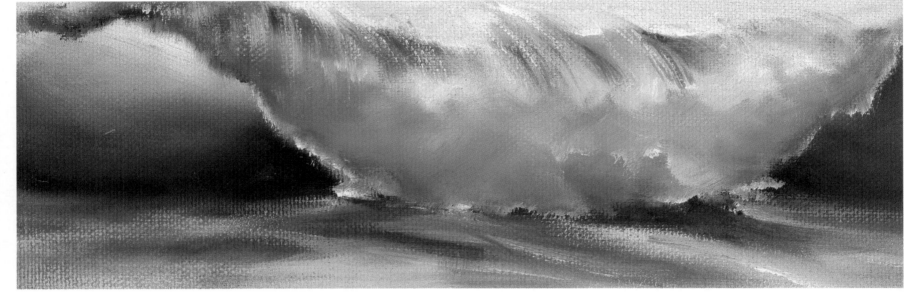

Instead of neutral white, warm burnt sienna and white were used on top of the foam area. A cooler mixture is used on the lower part.

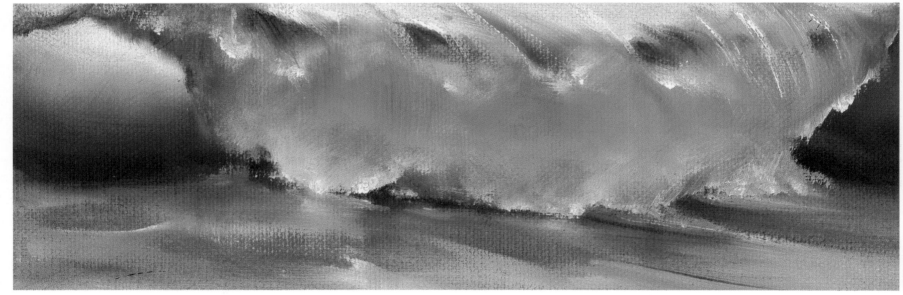

By exchanging the cool and warm areas on the foam, we have created the effect of light going through the foam area and reflecting on the shiny water in front of the breaking wave.

F. SHADOW IN FRONT OF BACK-LIT WAVE

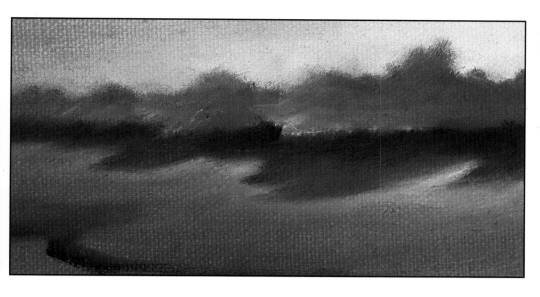

The shadow cast by a back-lit wave is another useful means of defining the form of the water surface. The shadow will follow the liquid configuration of a surface, just as the shadow of a tree falls across a dip in a road. Here the shadow indicates that the wave is riding in on a hill of water. This effect is dramatized by the light source being behind and to the far right of the wave. If you want to depict the water in front of the main wave as foreshortened (lines or areas represented as shorter than they actually are) by a preceding wave or water buildup, the shadow would also appear foreshortened—the opposite of what is shown here.

Note: At the point where the light source is the strongest or brightest, the meeting edges of the shadow and the object it falls across will have the most contrast—both warm versus cool and light versus dark. Notice also that the light glowing through makes the foam of the lower wave warm and light. In a larger painting, this warmth could then be reflected into the shadow area. Remember to show less detail in the area of the wave where the strongest backlight would be blinding.

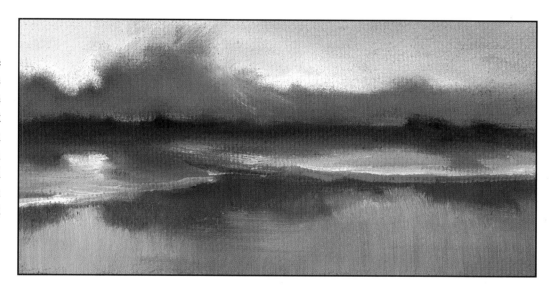

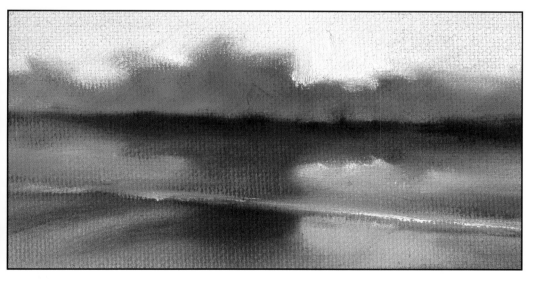

All of this can be further complicated by criss-crossing wavelets, which make it possible for lights and shadows to interact. A benefit to painting seascapes is that you can justify doing anything you like with a wave shadow.

A WAVE "PORTRAIT"

The instructions thus far have described the generic wave—one that lacks individuality and character. In order to make a seascape come alive, an artist must paint a "portrait" of a wave, discovering and rendering the characteristics that make it unique. Waves can be passive or aggressive and painted from a frontal or a profile view. Before painting waves, study them. Go to the beach and watch them roll onto the shore, look at photos in books and magazines, or study wave action on nature programs. Observe how they move; notice their different colors and moods. Pay particular attention to the light source and how it affects the shadows and highlights on the wave. Also, look at the sky; notice how it affects the character of the scene and how it makes you feel. Try to convey these feelings in your paintings of the sea.

PROFILE VIEW

A wave in profile is relatively easy to paint. I illustrate the profile here to emphasize the comparative difficulty of doing a frontal view wave portrait.

FRONTAL VIEW

A few characteristics of a frontal view include the foam patterns, the width of the shadow under the leading top edge, and the thinning of water as it peaks to pour.

PASSIVE WAVES

The waves to the right are considered passive. They portray a calm, soothing, relaxed mood.

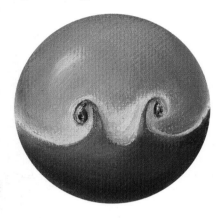

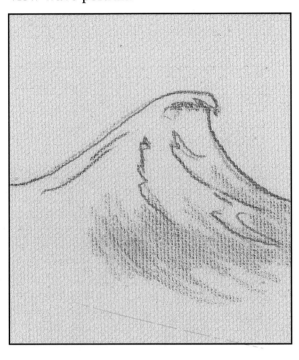

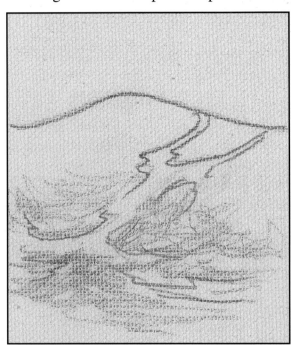

AGGRESSIVE WAVES

These waves are more aggressive than those above. They convey an exciting, stormy, turbulent feeling.

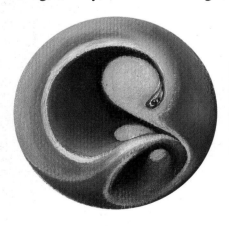

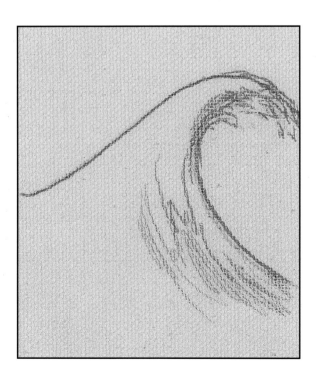

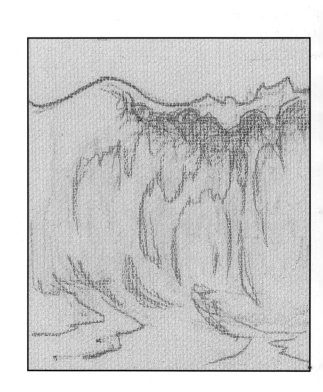

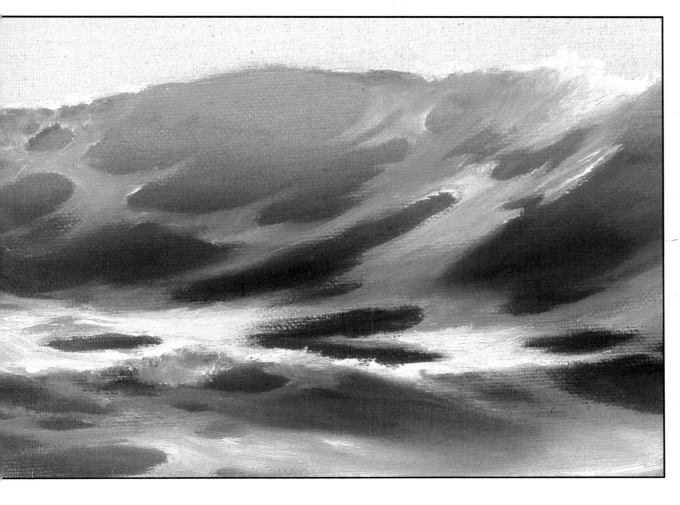

FRONTAL VIEW, PASSIVE

A #2 flat brush was used to drag lazy foam trails up (and, in the viewer's mind, over) this passive, laid-back wave face. As this wave breaks, the pouring water would slip and tumble casually down its sloping face.

FRONTAL VIEW, AGGRESSIVE

To suggest the fast sweep of pulled up foam on this aggressive wave face, keep the patterns blurred and think of them as being swiftly stretched upward. Trace the highlights to suggest reflected light glinting on the concave surface (another means of describing a wave's face shape).

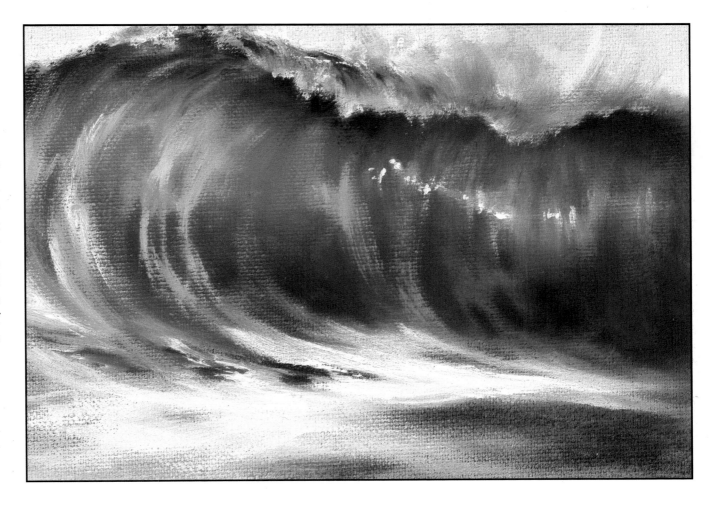

A BEACH SCENE

Wavelets and washes coming up on the beach are usually clear and shallow—they appear to be the same color as the sand adjacent to them. Therefore, you must make good use of their edges to portray what is happening. Notice that the foam edges are thicker where the water is deeper; the edges become thinner as the water becomes more shallow.

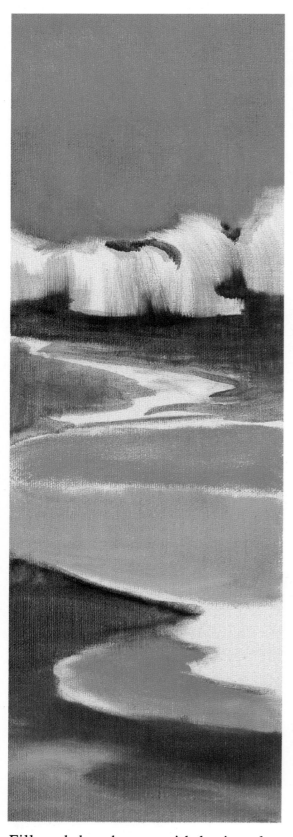 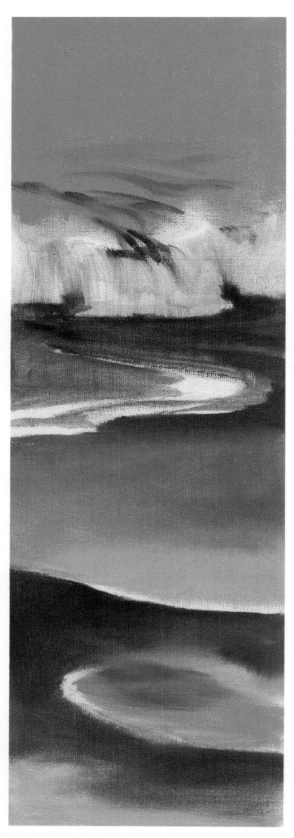 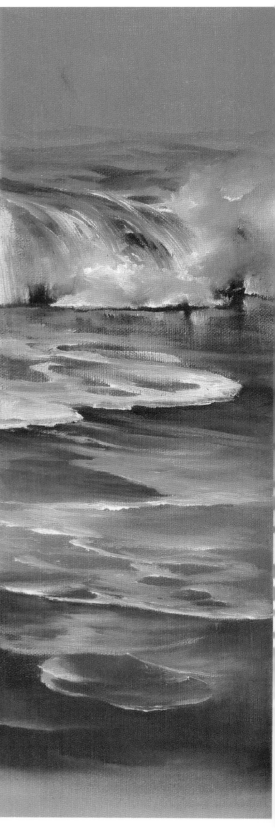

Fill each beach area with basic color, leaving the canvas bare where you will eventually place the white foam. Also leave a bare strip of canvas where two colors or values adjoin. The bare canvas allows for more control; the canvas texture helps to pull the paint off the brush during the blending strokes.

Join individual color areas using crosshatch strokes (described on page 3). As you work the beach washes—place dark color up under or to the edge of the foam, and then pull the light color back down to slightly overlap the dark areas—you will find the shape of the washes changing. If the shapes get too busy, you can easily brush out some of the detail.

Finally, describe the foam edges—the thicker ones can use some shading and/or pouring water similar to the large waves. Swirling, rhythmic foam patterns help to show movement. Check to see if you have eliminated enough edges to allow the viewer's eye to find a pathway through the painting.

PAINTING WET SAND

On a steep beach, the wash will often be so thin that it reflects for only a moment because part of it is already sinking into the sand. Here we are trying to catch that moment. The shadows cast from the stones on this shiny, wet sand will angle away from the light source and follow the slope of the surface(s) they hit. The reflection is pulled straight down toward the viewpoint, then shaded off by quickly lifting the brush. The length of the reflection will depend on the angle from which you are viewing the object, as well as the angle of the surface it reflects upon in relation to you. Observation is the best instruction where reflections are concerned.

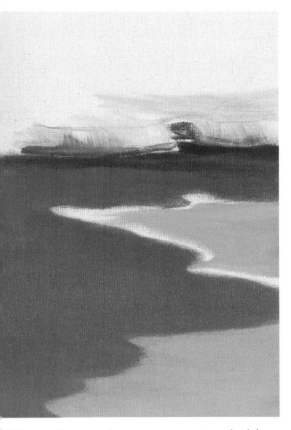 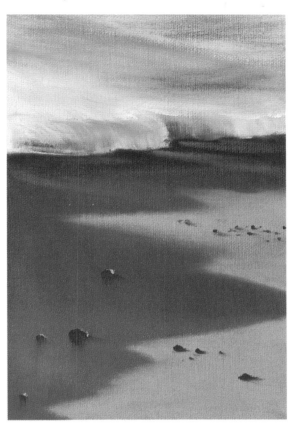 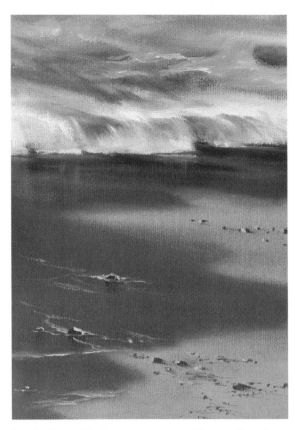

Where the sand appears wet and shiny, finish with a well wiped brush, pulling it downward in slightly overlapping, "feather touch" strokes, using either a flat or a fan brush. (Note: because of its curved edge, the fan brush is more difficult to control when starting the stroke in a critical area).

Where a shiny, wet wash joins a drier one or dry sand, pull the brush horizontally from the dry sand area, lifting the brush as you reach the shiny area to feather the adjoining edge. These strokes can be worked alternately, back and forth—wet down, dry across.

Lightly pull down some white reflections from the foam edge of the wavelet, trying to preserve the dark area just under the foam edge. The stone in the wet area has a light edge, indicating where the water meets the stone. Also, traces of foam and rivulets of water sometimes linger around stones. The wet pebbles need a white highlight. For the dry pebbles, indicate the light side with a lighter value.

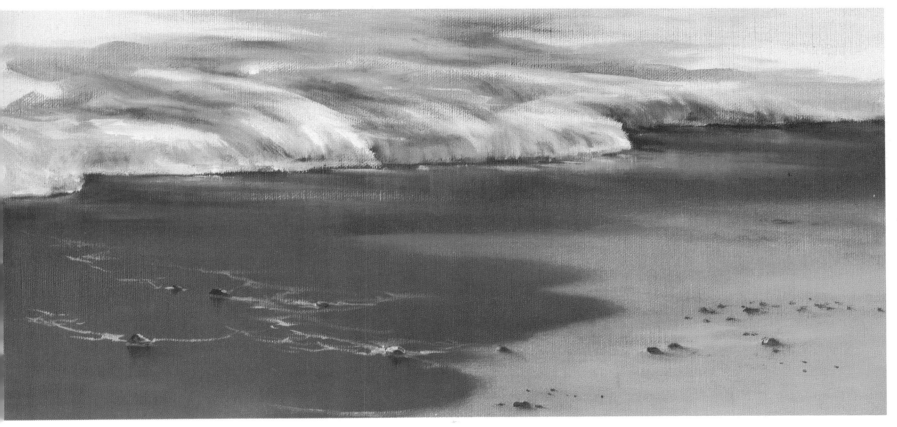

ROCKS

When painting rocks, try to show at least three distinct planes (flat surfaces), and have them face in different directions. If the rock was a box, for example, you could describe its shape best by showing three sides. If there was one light source, such as the sun, one of the surfaces would be lighter than the other two, one would be darker, and one would be the actual color (referred to as the "local color"). The more variety with which you intersect and vary the sizes and shapes of these planes, the more individual character this particular rock will have. Like waves, no two rocks are exactly alike.

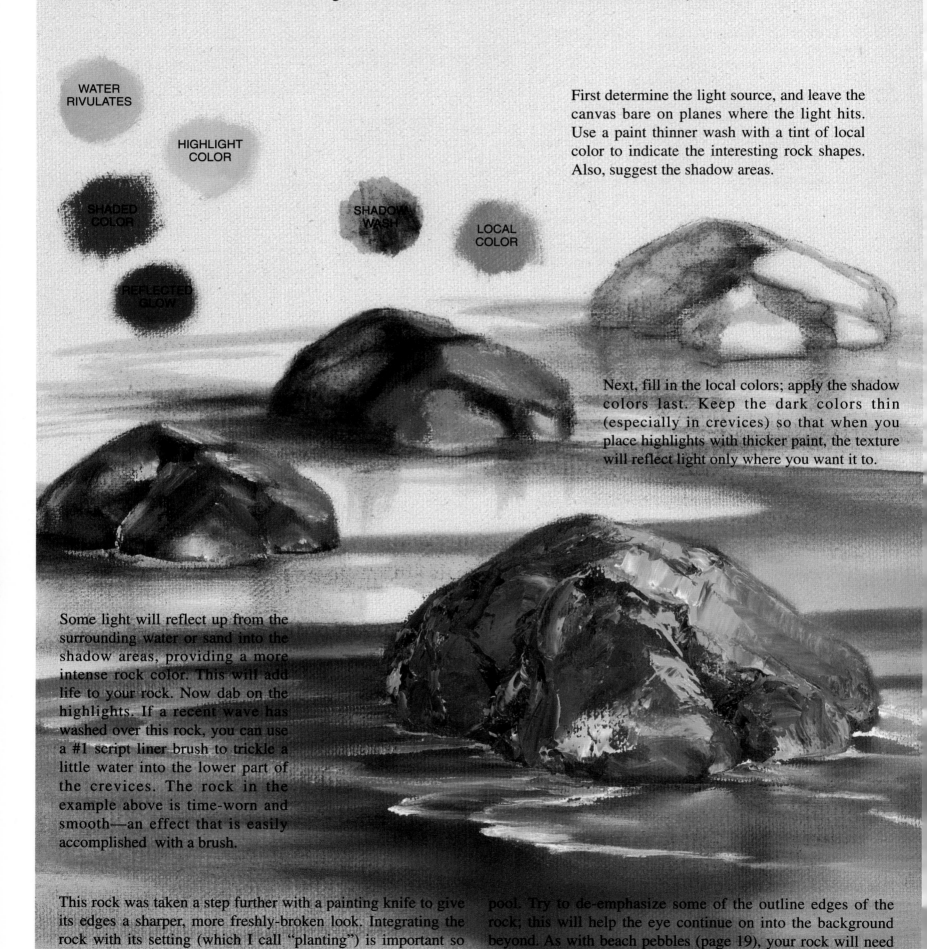

First determine the light source, and leave the canvas bare on planes where the light hits. Use a paint thinner wash with a tint of local color to indicate the interesting rock shapes. Also, suggest the shadow areas.

Next, fill in the local colors; apply the shadow colors last. Keep the dark colors thin (especially in crevices) so that when you place highlights with thicker paint, the texture will reflect light only where you want it to.

Some light will reflect up from the surrounding water or sand into the shadow areas, providing a more intense rock color. This will add life to your rock. Now dab on the highlights. If a recent wave has washed over this rock, you can use a #1 script liner brush to trickle a little water into the lower part of the crevices. The rock in the example above is time-worn and smooth—an effect that is easily accomplished with a brush.

This rock was taken a step further with a painting knife to give its edges a sharper, more freshly-broken look. Integrating the rock with its setting (which I call "planting") is important so that it doesn't appear to be floating in space. Wherever it rests, it should look partially buried or hidden. The wash around this rock suggests a steep beach, since it is not a placid reflecting pool. Try to de-emphasize some of the outline edges of the rock; this will help the eye continue on into the background beyond. As with beach pebbles (page 19), your rock will need a shadow and a reflection, as well as the edge highlights of water glinting here and there where the water meets the rock.

Atmospheric or aerial perspective refers to the phenomenon of objects appearing bluer, grayer, and, in most cases, lighter as they recede into the distance. To the artist, this means gradually losing local color (replacing it with paler and paler gradations of blue-gray) in relation to how distant you want an object to appear. If you want this headland to be farther away, you need to use a lighter, cooler value. Graduating the value and temperature changes (in defined steps) would change this distant headland into a receding shoreline. Shrinking the size proportionately would increase the effect.

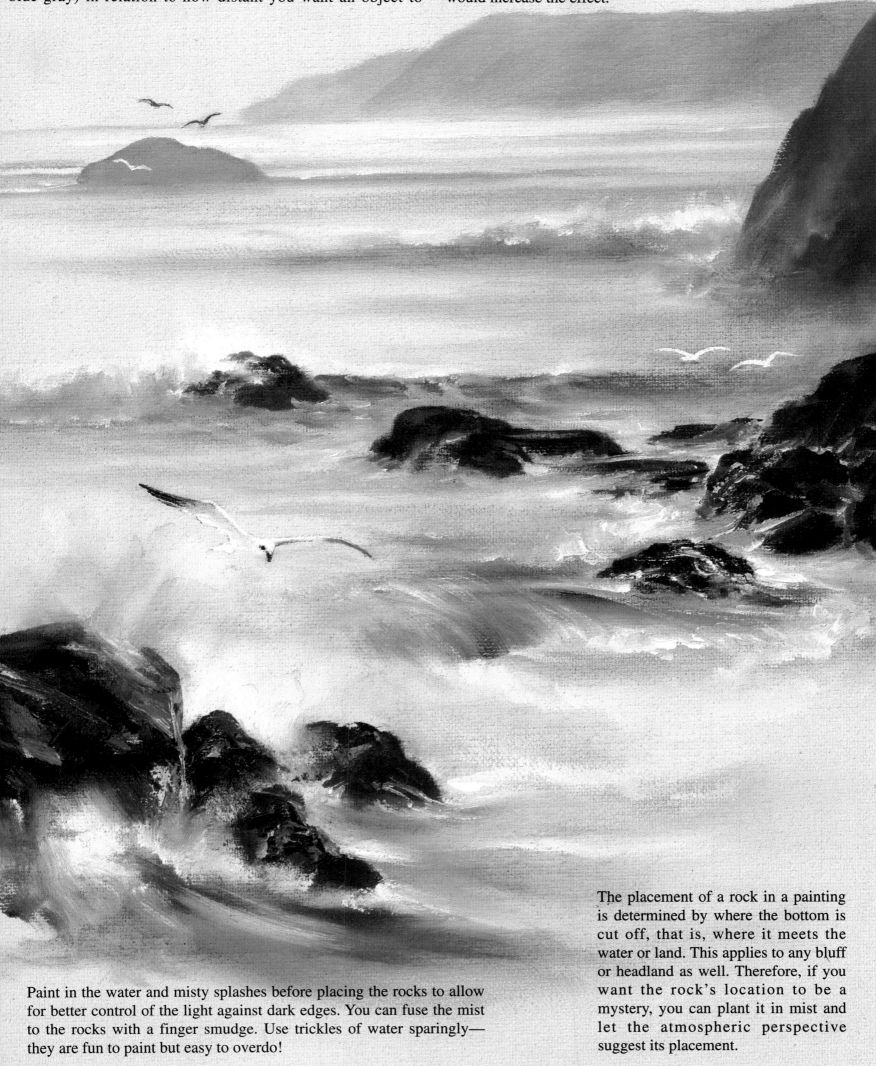

Paint in the water and misty splashes before placing the rocks to allow for better control of the light against dark edges. You can fuse the mist to the rocks with a finger smudge. Use trickles of water sparingly—they are fun to paint but easy to overdo!

The placement of a rock in a painting is determined by where the bottom is cut off, that is, where it meets the water or land. This applies to any bluff or headland as well. Therefore, if you want the rock's location to be a mystery, you can plant it in mist and let the atmospheric perspective suggest its placement.

FOAM PATTERNS ON FLAT WATER

Suggest the undulating movement of water with a rhythm of foam patterns playing across its surface. Wipe your brush often. As always, use the strongest contrasts of values and color wherever you want to create a focal point.

Place light foam on the dark area of the water. Determine the light source so you can use the shadow side of ripples and small waves to create interest in the foam patterns.

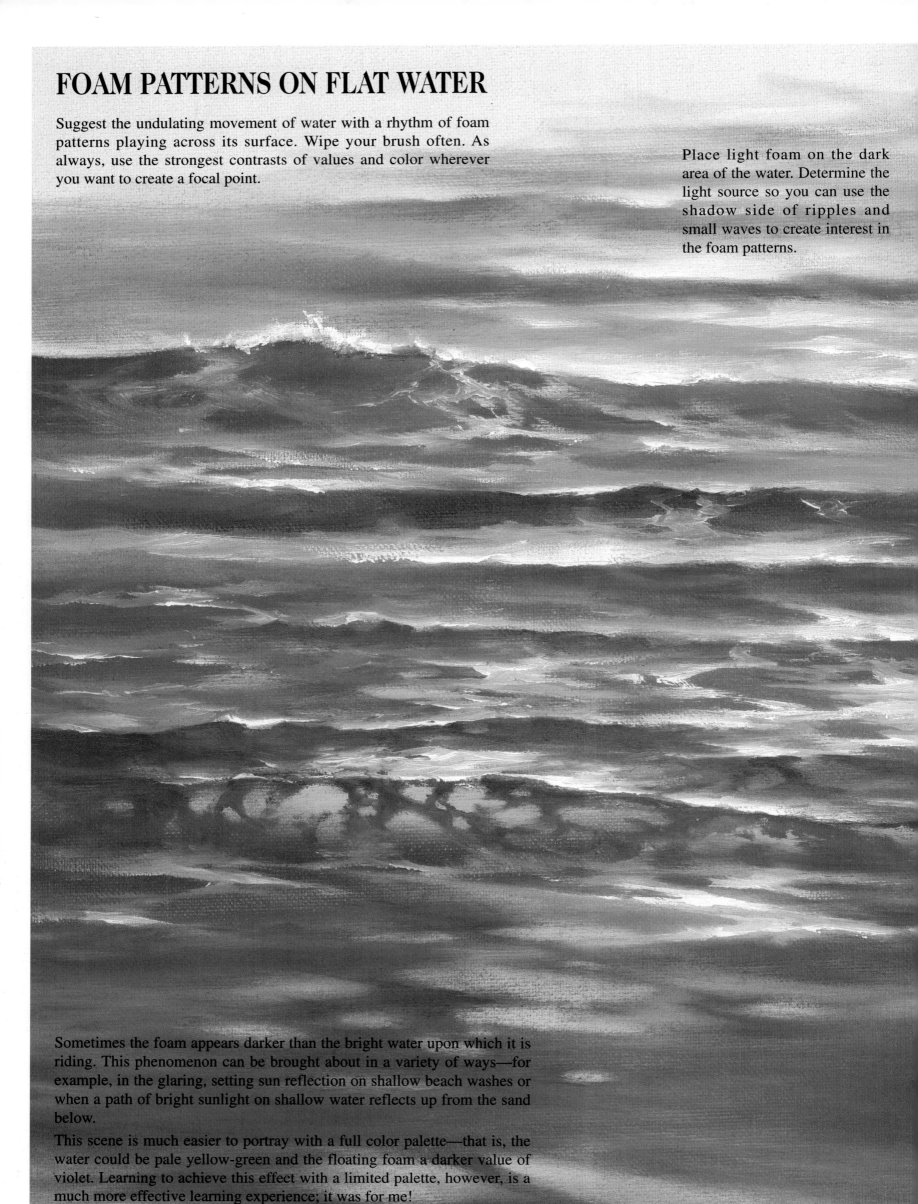

Sometimes the foam appears darker than the bright water upon which it is riding. This phenomenon can be brought about in a variety of ways—for example, in the glaring, setting sun reflection on shallow beach washes or when a path of bright sunlight on shallow water reflects up from the sand below.

This scene is much easier to portray with a full color palette—that is, the water could be pale yellow-green and the floating foam a darker value of violet. Learning to achieve this effect with a limited palette, however, is a much more effective learning experience; it was for me!

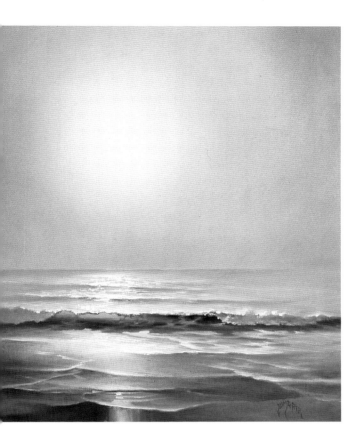

MOOD AS AFFECTED BY WEATHER

California fog sometimes rolls in at sunset. Maybe the spectacle of fog swallowing the sun is such a treat because we can watch without being blinded. The hot red, pink, and orange glowing colors of the sun are the ultimate contrast to the wet, cool fog engulfing it. You can almost hear the sizzle—try to paint it that way.

FOG SETS THE MOOD

Fog is a great excuse for not having to make decisions about the horizon and sky. Mix warm and cool misty colors. Unless a dark area is blocking out the light source, most of the painting will be in subtle, muted colors without strong contrasts. The less light, the less shadows. To dramatize this painting, you can create a hole in the fog and let strong sunlight pour in where you choose.

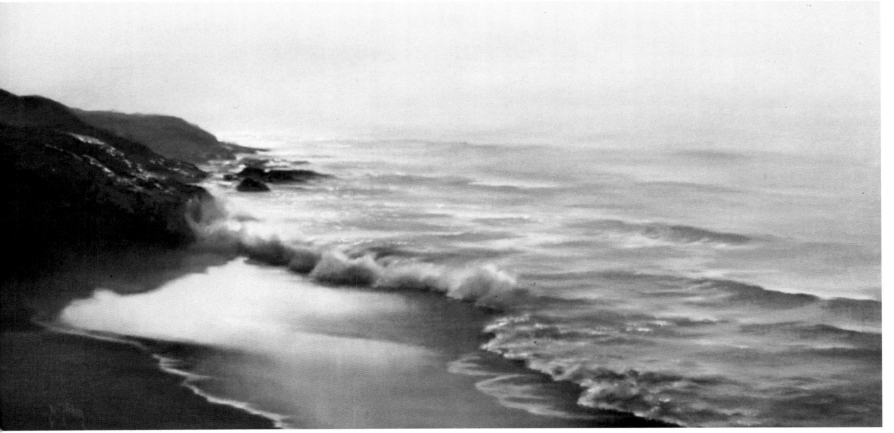

RAINBOWS

While watching breaking waves, you will occasionally be treated to a visual delight when a fragment of jewel colors appears in the mist. I prefer to paint this prism of light rather than the predictable, showy rainbow, because, if done subtly, it can be the same delightful surprise that it is in nature.

A prism is normally added as an accent, so there will usually already be a misty area into which you can work the colors. (Note: To make the demonstration below clear, I painted obvious bands of color; in an actual painting, however, I apply only tiny dots of pure color.) Blend the prism colors with delicate crosshatching, wiping the brush often so as not to dull the colors. Once the colors are blended to your satisfaction, use a clean brush to make a horizontal stroke out from the yellow to one side of the prism. Then wipe the brush and draw out from the yellow to the other side. This will fuse the colors. Finish by blending the edges of the prism into the surrounding mist. If needed, continue making alternate vertical and horizontal strokes (wiping your brush often) until you are satisfied.

Rainbows Reflecting

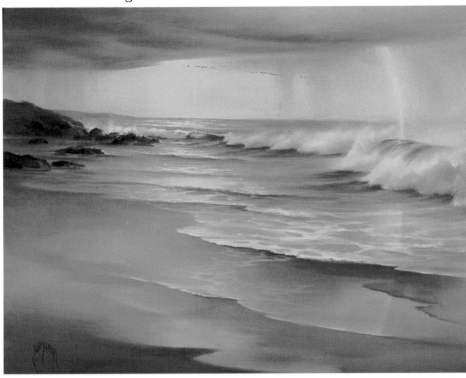

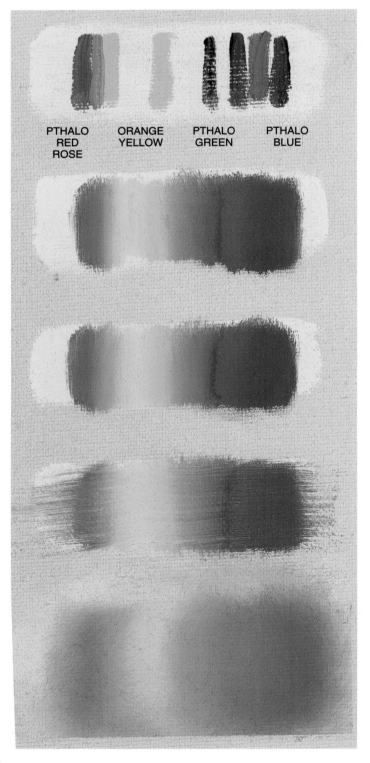

PTHALO RED ROSE ORANGE YELLOW PTHALO GREEN PTHALO BLUE

A Subtle Fleeting Prism

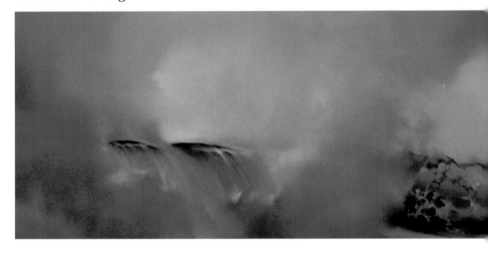

Bursting Rainbow

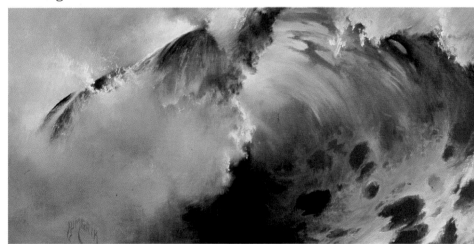

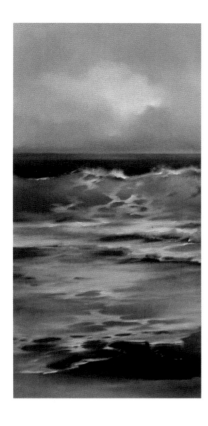
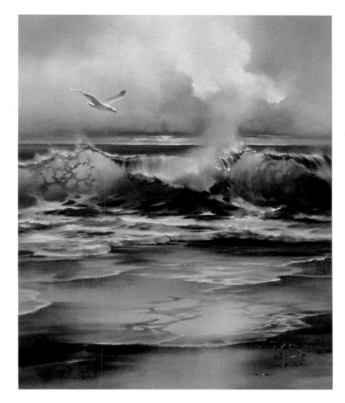
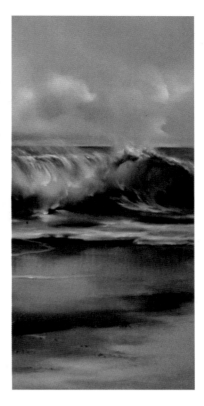

BRIGHT SUNLIGHT

To depict the mood of the painting above, keep the colors bright, clear, and crisp. All the colors used in this palette are combinations of those listed on page 3. In the areas where colors flow together visually, further combining of these mixtures will produce some lively neutrals that work as foils for the bright colors.

The brighter the sunlight, the darker the shadows. The darkest darks are made from a combination of pure pthalo red rose, pthalo green, and pthalo blue, only slightly combined so that lively bits of color jump out here and there. (The dark color mix is shown on page 26.) Use this intense mix only for the darkest, deepest places in your painting—such as the dark base of the wave. For the other shadow areas, use bright, cool combinations, as shown at the bottom of the palette above (darkened in value as needed). Since the light playing on the water in the bright sunlight is so reflective and strong, use an intense dark (value 10) to show how light everything else is in comparison.

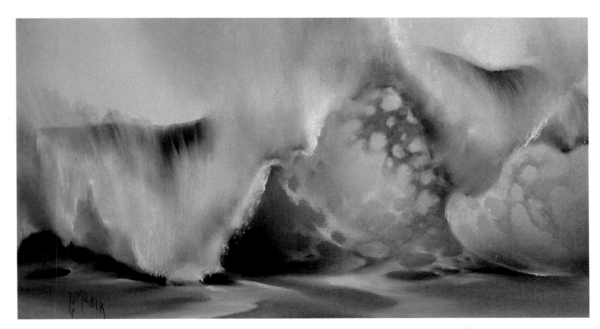

SUNSETS

Sunsets provide the perfect opportunity to mix all those beautiful warm, muted colors to play against their grayed complements in long, exaggerated shadows. Complementary colors are any two colors directly opposite on the color wheel—for example, red and green or blue and orange. (This also applies to any adjacent hues you mix.) If you do not add white, any two complements can be mixed together in varying amounts to appear black. If you wish to gray a color, add a touch of its complement. Continued additions of the complement, along with some white, will make a neutral gray. This method of mixing grays results in clean, lively neutrals. Use the grayed complement of a color for its shadow to help keep your painting lively and glowing.

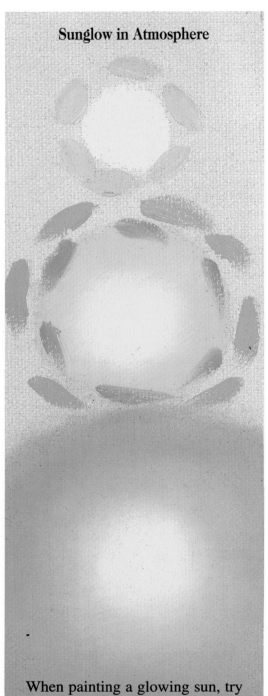

Sunglow in Atmosphere

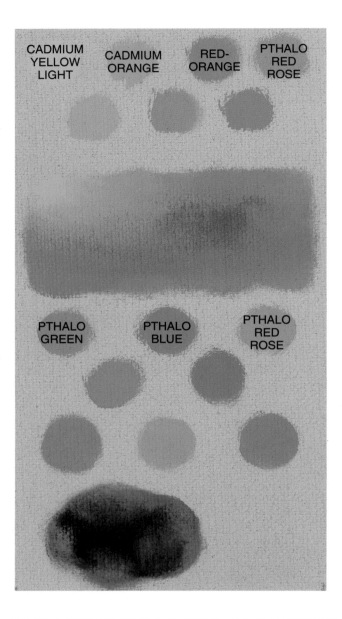

CADMIUM YELLOW LIGHT CADMIUM ORANGE RED-ORANGE PTHALO RED ROSE

PTHALO GREEN PTHALO BLUE PTHALO RED ROSE

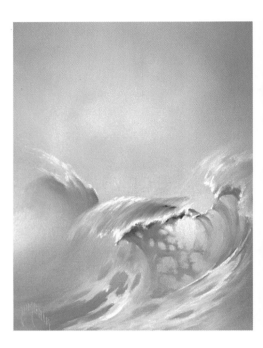

Placing complementary colors of equal value next to each other will make the colors seem to "vibrate." You can make good use of this optical phenomenon when painting a sunset. Keep in mind, however, that colors appear bright only in relation to the dullness of their surroundings, and they can easily look garish. What Nature does so eloquently with light, we can only suggest with paint.

When painting a glowing sun, try to avoid dragging the newly added color into the former one as you blend the hues into a progressively broader area. Try to pull the mixtures outward, using crosshatched strokes. The final application in this example is pthalo green and white, which is blended into the former mixture of pthalo red rose and white, which had been mixed into red-orange, which had been added in dabs into a blending of the cadmium orange and white mix fused with the cadmium yellow light and white center.

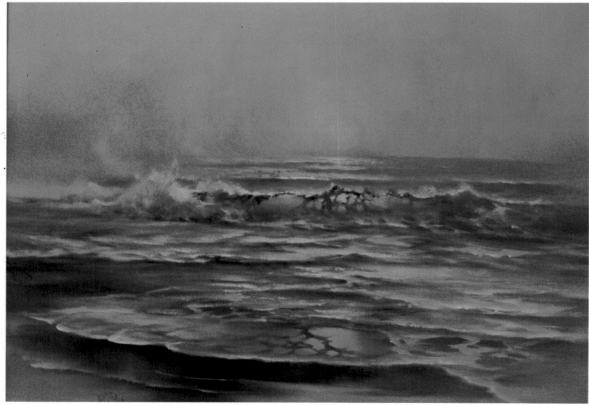

MOONLIGHT

This is one of the most important times to use your skills in observing subtle value changes. This palette contains mixtures using white, yellow, orange, pthalo red rose, pthalo green, and blue-black. Use a touch of pthalo red rose with cadmium orange for graying the blue-black and green; use this combination also to keep the blue-black from being too cold in the darker areas. Take caution to avoid creating a "dead" black color; instead, try for a lively range of grays (see page 26).

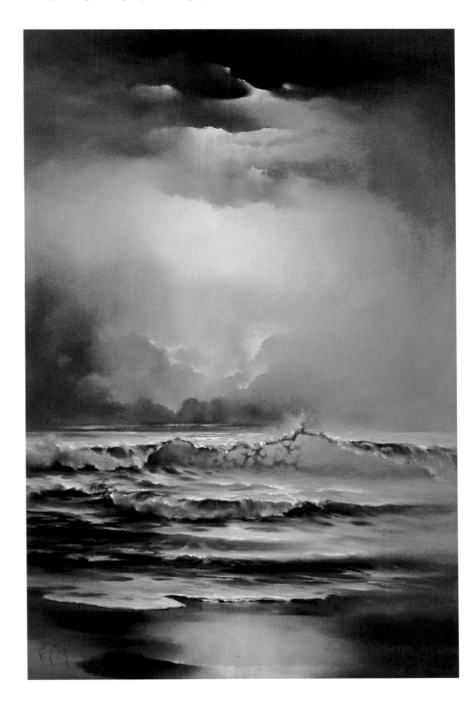

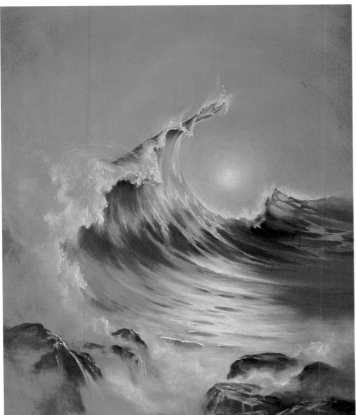

In a bright, moonlit sky, the light usually appears orangish-white. Yellow should be used very sparingly when painting a moonlight scene. Save that very bright white/yellow color for sparse highlights on the water—such as where the moonlight shimmers in a path on the water or touches on a beach wash.

IMAGINARY LIGHT

After all the discipline in regard to creating natural light effects, it can be fun to break away and do something playful and imaginative. You can confound your visual sensibilities by making up a light source—such as one coming from inside the water. The better you understand the effects of real light, the more believable you can make the UNREAL ones.

The colors you choose for this type of painting can be just as imaginative as the light source. Using unlikely color combinations can make your "unreal" paintings even more intriguing. Have fun making the seemingly impossible believable!

Block in the colors in all areas of the painting, leaving bare canvas where the colors will meet in blending.

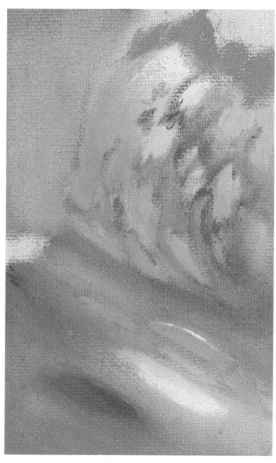

Blend the adjacent areas of color together. Paint the drawn-up foam and floating foam patterns.

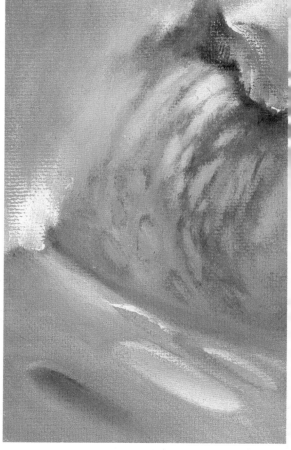

Add detail, highlights, and restate the darks. Be sure to leave some "indistinct edges" to allow the confounded eye to slip through!

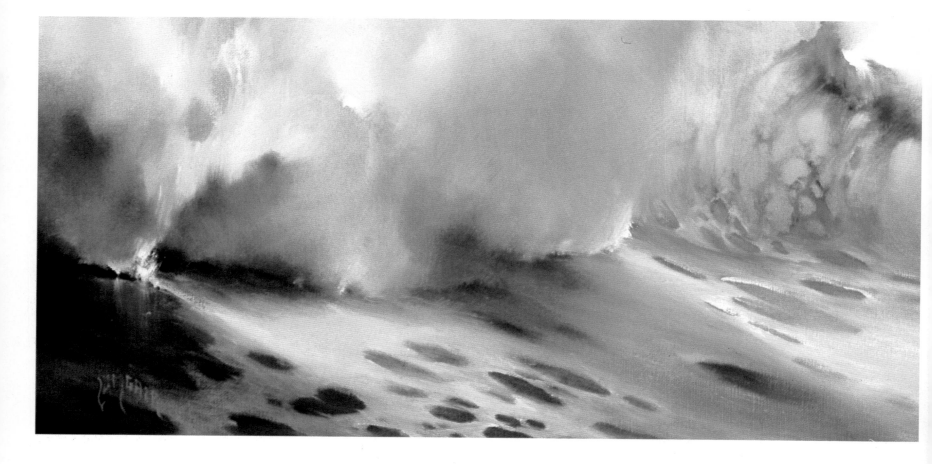

CLOSE-UPS

Sometimes it is refreshing to start a painting by mixing colors that just seem to feel good that day—no planning, no drawing. Apply the colors to the canvas in a nonchalant yet balanced color arrangement, and then go wherever it takes you. The source of inspiration in my paintings is usually water—sometimes in an "other-worldly" way! These paintings are the ones I find most enjoyable.

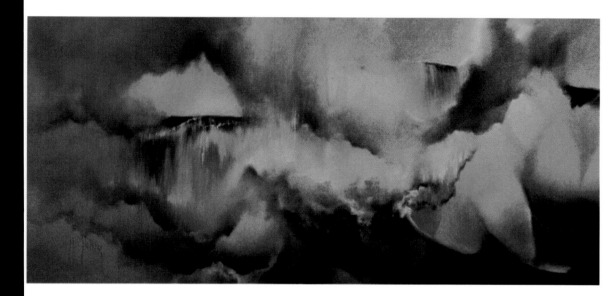

If nothing suggests itself by the time you have covered the canvas with paint, step back, turn the canvas upside down, and search for a new perspective. Don't become discouraged; maybe you're simply not in an "imaging" mood. Rather than let the paint on the canvas dry, making it that much less inviting the next time you put it on your easel, go ahead and do a traditional seascape painting, using a photo or sketch for inspiration.

Start by mixing a strong dark base (pthalo blue, pthalo green, and pthalo red rose, barely mixed); use it to suggest the darkness under a breaking wave. Now, with another brush (you don't want to spend your painting time rinsing brushes), pull some white up from the dark area to represent frothy water. Now you won't be able to put this painting aside!

If you do go "mind surfing" (by simply letting the painting "happen"), here are some tips to help make it successful: It should have all the components of a good painting—balance, contrast, exciting eye path, lost edges, neutrals to keep your bright colors palatable, etc. To freshen your eye, turn the abstract painting in all directions to check these components; they should apply no matter which way it is viewed. You can also hold the painting up to a mirror and view it in reverse. This is good practice because any problem areas will jump right out. Be open to the possibility that a painting may be more exciting if viewed from a different side than the one you had planned. Don't hesitate to scrape off paint and make drastic changes. A masterpiece may emerge from beneath that last layer of paint!

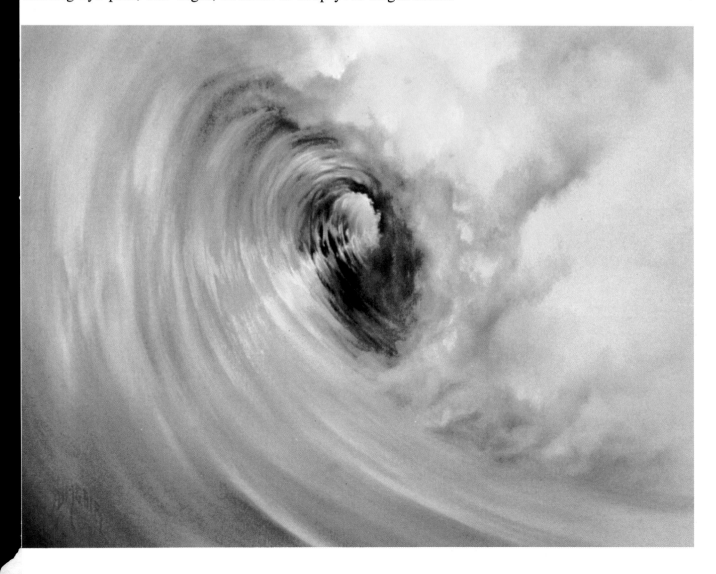

SEASCAPES FLOW INTO ANY FORMAT

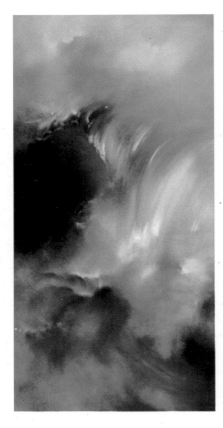 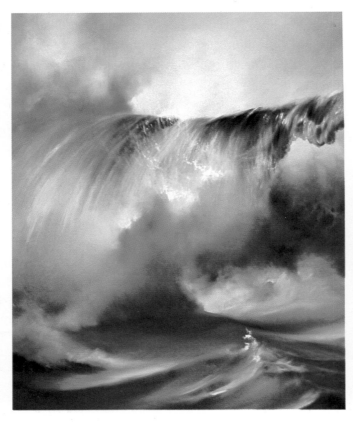 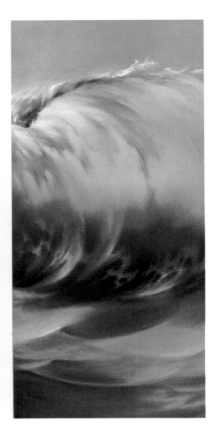

A **triptych** is a three-panel painting. About fifteen years ago I was inspired by a three-panel wooden church icon in an Art History class. I wondered how a seascape would work in a triptych—the format would provide strong verticals (which I was always searching out), it would encourage a broader view (looking up and down the beach), and, best of all, the side panels can be used to direct the viewer back to the center panel. What a perfect format for a seascape! I have so enjoyed expanding my seascapes into this format that I often feel confined using just one canvas. What a travesty that this perfect format has been usurped as a "decorator gimmick," by thoughtlessly chopping one painting into three sections. This format has been with us for 4000 years, and, used appropriately, I'm sure it will survive.

Here is a vertical triptych using three different perspectives— looking down, looking out, and looking up. The panels can be displayed in combination or separately.

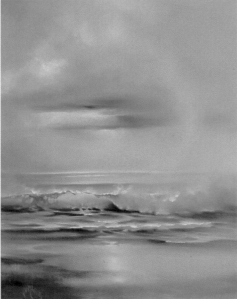

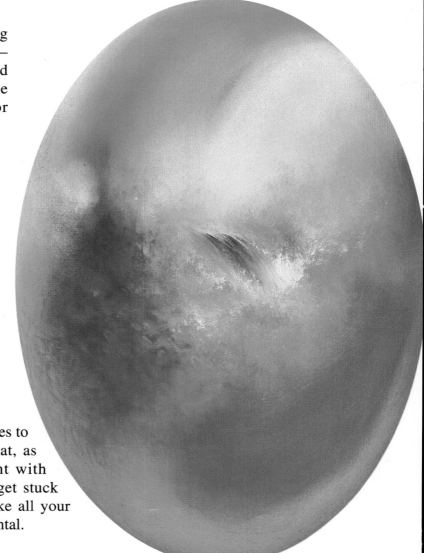

Waves also lend themselves to a circle or an oval format, as shown here. Experiment with various formats—don't get stuck in a creative rut and make all your seascape paintings horizontal.

VISUALIZE JUST AHEAD OF YOUR BRUSH. . .
GO WHERE IT TAKES YOU!

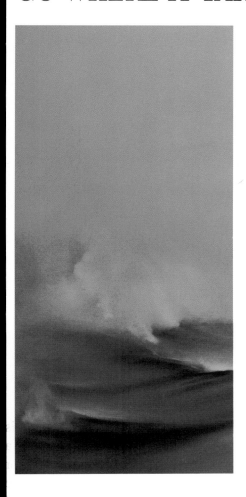 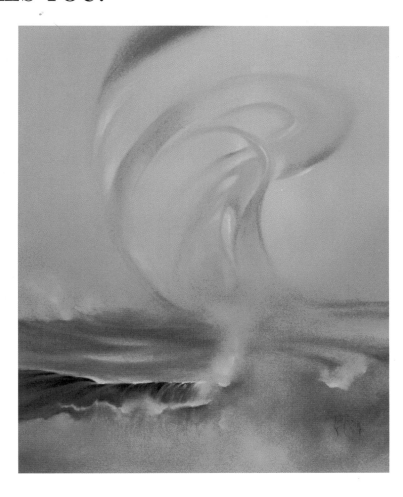

In this book, I frequently refer to the "viewer." Art is a form of communication, and with it we can bypass awkward, inadequate language constraints and go right to the heart, the jugular, the button. For example, I often play soft jazz while painting. One day a man studied one of my paintings for a long while and then turned to me and asked, "You like soft jazz, don't you?" I had goose bumps while he went on to explain that he is a musician and could feel the rhythm in the painting.

Another day while painting in my gallery, I looked up from the canvas to see two young teenage girls sitting on the floor, chins on hands, quietly engrossed in the paintings. In answer to my puzzled intrusion, they said, "Oh, we're dancers, and we feel the dance in your paintings." I know the people who are receiving what I am sending by the looks on their faces. Painting is such a wonderful, deep, non-verbal communication—it is why I paint and why I am concerned about your "viewer."

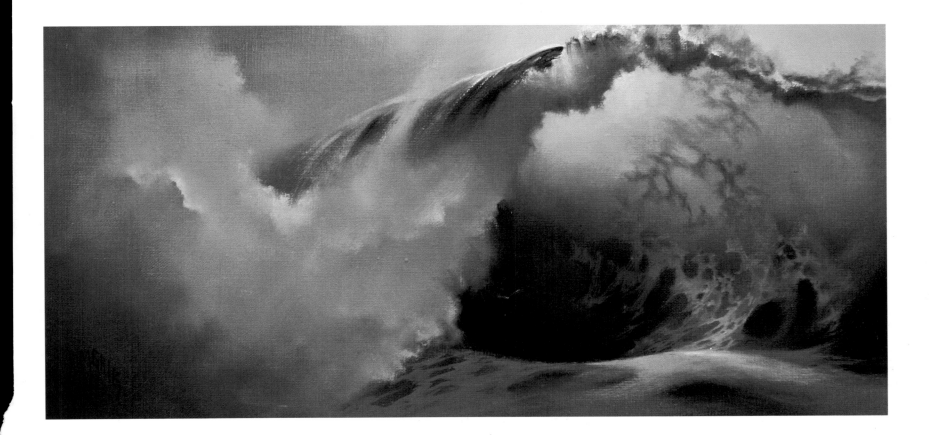

Walter Foster Art Instruction Program

THREE EASY STEPS TO LEARNING ART

Beginner's Guides are specially written to encourage and motivate aspiring artists. This series introduces the various painting and drawing media—acrylic, oil, pastel, pencil, and watercolor—making it the perfect starting point for beginners. Book One introduces the medium, showing some of its diverse possibilities through beautiful rendered examples and simple explanations, and Book Two instructs with a set of engaging art lessons that follow an easy step-by-step approach.

How to Draw and Paint titles contain progressive visual demonstrations, expert advice, and simple written explanations that assist novice artists through the next stages of learning. In this series, professional artists tap into their experience to walk the reader through the artistic process step by step, from preparation work and preliminary sketches to special techniques and final details. Organized by medium, these books provide insight into an array of subjects.

Artist's Library titles offer both beginning and advanced artists the opportunity to expand their creativity, conquer technical obstacles, and explore new media. Written and illustrated by professional artists, the books in this series are ideal for anyone aspiring to reach a new level of expertise. They'll serve as useful tools that artists of all skill levels can refer to again and again.

Walter Foster products are available at art and craft stores everywhere.

For a full list of Walter Foster's titles, visit our website at www.walterfoster.com or send $5 for a catalog and a $5-off coupon.

WALTER FOSTER PUBLISHING, INC.
23062 La Cadena Drive
Laguna Hills, California 92653
Main Line 949/380-7510
Toll Free 800/426-0099

www.walterfoster.com